Happy Little Accidents

the WIT and WISDOM of

Bob Ross

compiled by *Michelle Witte*

RUNNING PRESS
PHILADELPHIA

Running Press
Hachette Book Group
1290 Avenue of the Americas,
New York, NY 10104
www.runningpress.com
@Running_Press

Printed in China

First Edition: May 2017

Published by Running Press, an imprint of Perseus Books, LLC, a subsidiary of Hachette Book Group, Inc. The Running Press name and logo is a trademark of the Hachette Book Group.

The Hachette Speakers Bureau provides a wide range of authors for speaking events. To find out more, go to www.hachettespeakersbureau.com or call (866) 376-6591.

The publisher is not responsible for websites (or their content) that are not owned by the publisher.

Photo credits: squirrel (cover) © Gettyimages.com/itsjustluck; paint swashes (cover and interior) © Thinkstock.com/barbaliss and Thinkstock.com/zoom-zoom; squirrel silhouette (p. 20) © Gettyimages.com/ace_creative

Print book cover and interior design by Ashley Todd

Library of Congress Control Number: 2016959714

ISBN: 978-0-7624-6278-0 (hardcover), 978-0-7624-6279-7 (ebook)

RRD-S

14 13 12 11 10

Introduction

Bob Ross is a man best known for his hairdo and his hobby, but anyone who has stopped for a moment and listened to Bob while he went about his painting knows that he is so much more than that. While his iconic catchphrases—and equally iconic hairstyle—made Bob Ross a cultural phenomenon for the past thirty years, it is the nuggets of knowledge in his gentle chatter that captivated audiences.

Viewers tuned in every week for more than a decade to see him create a masterpiece in half an hour while dispensing little branches of wisdom. More recently, he's found a resurgence in popularity with the advent of the Internet and online streaming. The joy that Bob found in painting has been given new life by a younger generation.

Part of Ross's lasting appeal is that he talked about more than paint and landscapes and trees—he tapped into the core ideal that people should be happy, and painting was a great way to achieve that. There was hidden depth within his easy banter, another layer to everything he said. When he talked about

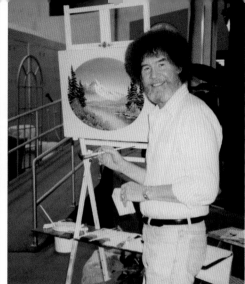

painting, he used it as a metaphor for life. Viewers can see that joie de vivre in everything Bob did, and they are grateful for it.

Perhaps most important, he championed the idea that painting—and finding joy—is something everyone can do, whether they're a beginner with no discernable talent or an expert who's been painting for years. It isn't about the art so much as it is the *doing*.

This is the essence of Bob Ross, and the inspiration for this tribute to him. Find a little joy amid the hustle and bustle of modern life. Stop for a moment to appreciate the beauty of nature. Take time to simply breathe. And most of all, remember that there are no mistakes in life, just happy little accidents.

As Bob would say: Happy painting, and God bless.

Biography

Robert Norman Ross entered the world on October 29, 1942, in Daytona, Florida, the son of a carpenter named Jack and a waitress named Ollie. Bob's childhood was somewhat turbulent. By the time he was a teen, his parents had separated, married other people, and subsequently divorced those partners to marry each other again. The second attempt at marriage didn't last long, however, as Jack died not long after.

Although Bob lacked a formal education, it did little to hinder his success in life. He dropped out of school in the ninth grade to work with his father as a carpenter. During that time, he cut off one of the fingers on his left hand. Years later he would hide the injury by carefully holding his palette so that it wouldn't show on camera.

At the age of eighteen, he enlisted in the U.S. Air Force. He married his first wife around that time, but it didn't last long. It did, however, give him a son, Steven, whom he raised alone for many years. Steven was still young when Bob received a new assignment, which took them to Eielson Air Force

Base in Anchorage, Alaska. Bob instantly fell in love with the rugged beauty of Alaska's mountains. For a boy raised in Florida, seeing mountains and snow for the first time—the polar opposite of the tropical weather and sandy beaches back home—left a deep and permanent impression on him. Those mountain and wintry landscapes would dominate Bob's art for the rest of his life.

It was in Alaska that Bob met another important love in his life: Jane Ross, a civilian worker in the Air Force who would become his wife and would help raise Steven.

Ross's foray into painting began during an art class at the USO club in Anchorage, and it quickly became a passion for him. To supplement his modest income in the Air Force, he painted mountainscapes in gold pans that he would sell to tourists at the tavern where he worked at night. One night while tending bar, he saw a TV show starring German painter Bill Alexander. Bob was captivated by the simple technique of wet-on-wet painting. Originally known as *alla prima*, this method, dating back to the 1600s, allowed artists to complete an oil painting in less than an hour, whereas traditional oil painting can take days to finish, as each layer is allowed to dry before the next is added.

Before long, Bob's profits from painting, as well as money he earned by offering painting lessons, outstripped his military salary, so after serving for twenty years he left the Air Force to focus on art full-time.

Ross became known for his tranquil, almost hypnotic way of speaking on TV, and it was his time in the military that led him to cultivate those soft vocal tones and tranquil demeanor. As a drill sergeant, he was "the guy who makes you scrub the latrine, the guy who makes you make your bed, the guy who screams at you for being late to

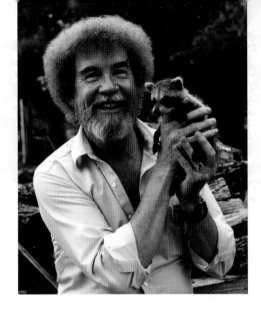

work." Bob hated having to be mean, so he decided that once he left the military, he would never yell again.

Another of Ross's most defining and iconic traits is one that he liked least: his hair. During his career in the military, he kept his hair in the requisite buzz cut. Short on funds after retiring from the Air Force, Bob decided to get a perm so he wouldn't have to pay for weekly trips to the barber. He later grew to hate the hairstyle, but by that time it had already become a signature part of his brand, and so the 'fro stayed.

After leaving the military, Ross tracked down Bill Alexander and studied with him before traveling across the country teaching some of Alexander's painting classes. It was in one of those classes that Ross met Annette Kowalski, who became instrumental in getting *The Joy of Painting* on the air. She paid Ross to teach classes in Virginia, where she lived with her husband, Walt, and eventually helped Bob land a slot on the local PBS station.

The Joy of Painting premiered on WNVC on January 11, 1983, though it took several years before the show drew a large following. It was a slow process, but Bob was determined. When things didn't work out after the first season

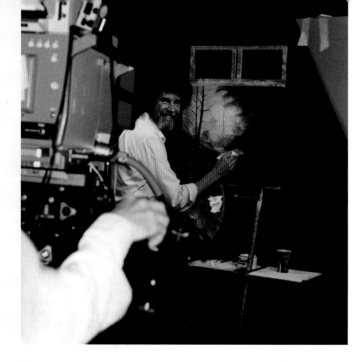

the paintings created for the show either. Those were mostly given away to charities or to PBS stations to use in funding drives. The exact number of paintings created in his lifetime is unknown, but it's estimated at more than thirty thousand.

By the end of its storied run, *The Joy of Painting* boasted thirty-one seasons with more than four hundred episodes, which aired on more than 275 television stations across the globe, first in Canada and then branching out to the United Kingdom before spreading to European nations. Eventually, the show would be translated to air in international countries including Japan,

with WNVC, they found a new home in Muncie, Indiana, with PBS station WIPB.

Ross didn't earn any money from taping the show. Instead, his income came via the official Bob Ross art supplies and instruction books he sold. He didn't sell

South Korea, Mexico, Costa Rica, Turkey, Iran, Taiwan, Colombia, the Netherlands, Thailand, Germany, Greece, Switzerland, Belgium, and Austria, with inquiries emerging from other countries to this day. In each of the translations, Ross's running commentary was kept intact; even though international viewers might not understand what Bob was saying, they were captivated by his gentle manner of speaking.

In 1992, Bob's wife, Jane, succumbed to cancer; he followed her to the grave just a few years later. At the time of Jane's death, he was beginning to show weakness from his own battle with cancer. It was his second bout of lymphoma, which he hid from all but his closest friends. He'd been in remission for many years after a surgery to remove the cancer long before he started *The Joy of Painting*. But by 1994, the cancer was beginning to take its toll. He tired easily, and soon it became too difficult for Bob to travel from his home in Florida to the studio in Indiana where the show was filmed. In those final episodes, Bob wore a wig to retain his trademark hairstyle for his viewers. The last episode aired May 17, 1994. He died less than a year later, on July 4, 1995, at the age of fifty-two.

And still his legacy endures. Certified instructors teach the Bob Ross method of painting to budding artists across the world, and his how-to guides and painting supplies remain popular. New generations are discovering the gentle-voiced painter and his happy little trees via a medium that didn't exist in Bob's lifetime: video streaming online. *The Joy of Painting* is arguably the most popular TV show about art that the world has seen, and for good reason: Bob's paintings—and lessons—are timeless, as is the man himself.

*"Anything we don't like,
we'll turn it into a
happy little tree or something;
we don't make mistakes,
we just have happy accidents."*

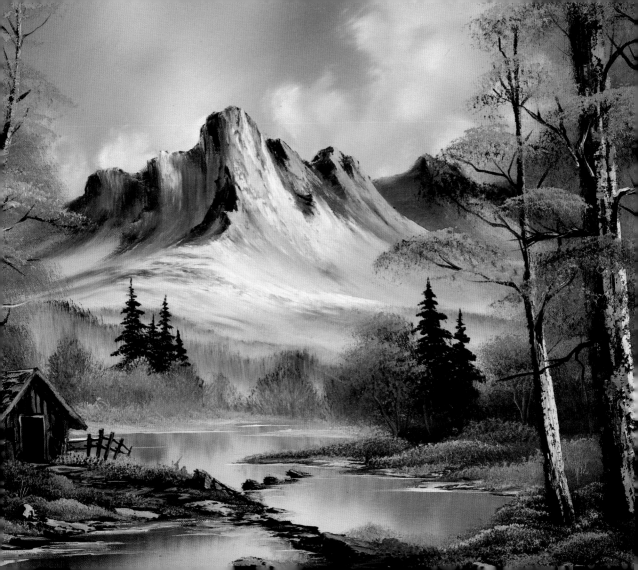

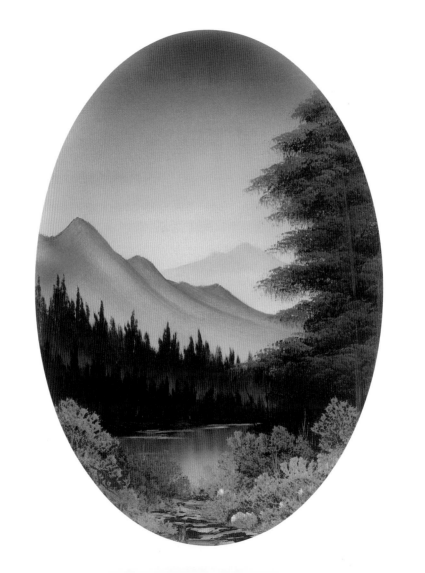

"We begin with paint and brush. The object is to capture the dream quickly, while it is still alive."

**"Isn't that fantastic?
I knew you could do it."**

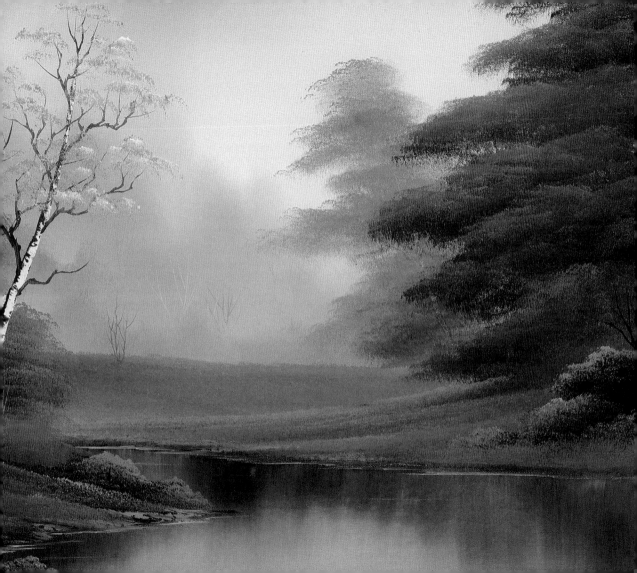

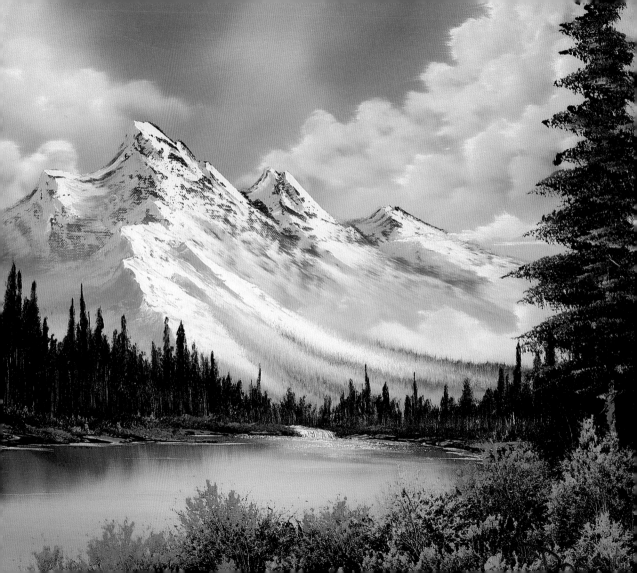

"... that may be the true joy of painting, when you share it with other people. I really believe that's the true joy."

"I aspire to create tranquility, a peaceful atmosphere to take people away from their everyday problems and frustrations."

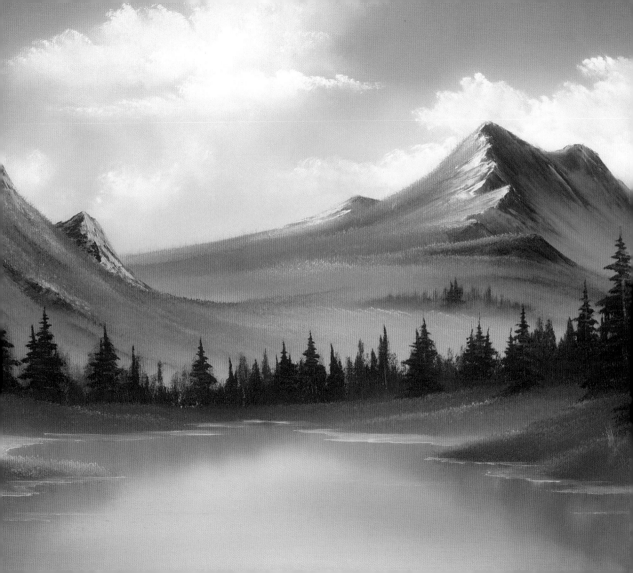

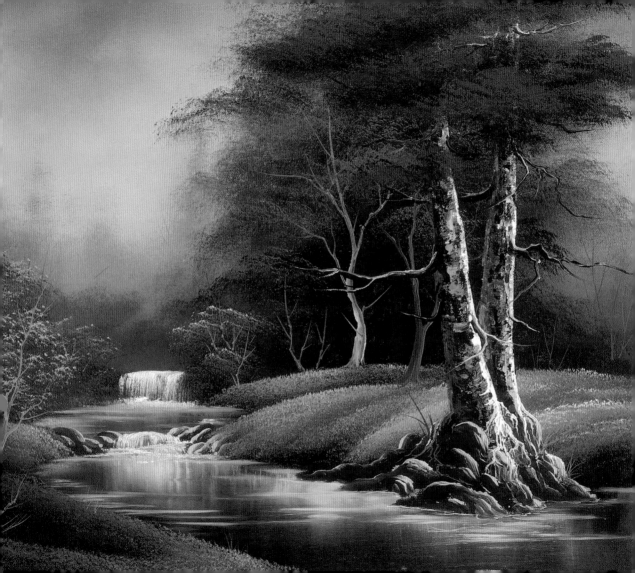

"Friends are the most important commodity in the world. Even a tree needs a friend."

"If we all painted
the same way,
what a boring world
it would be."

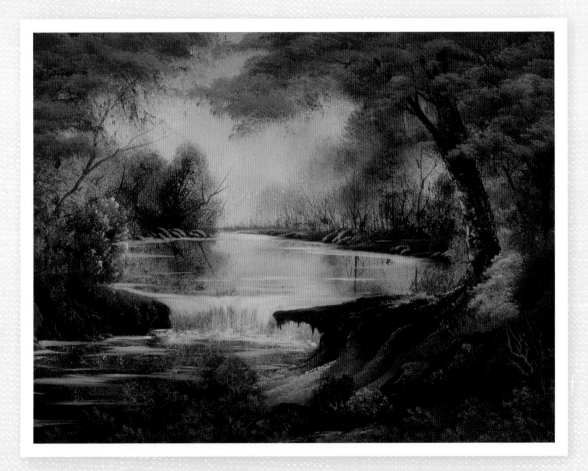

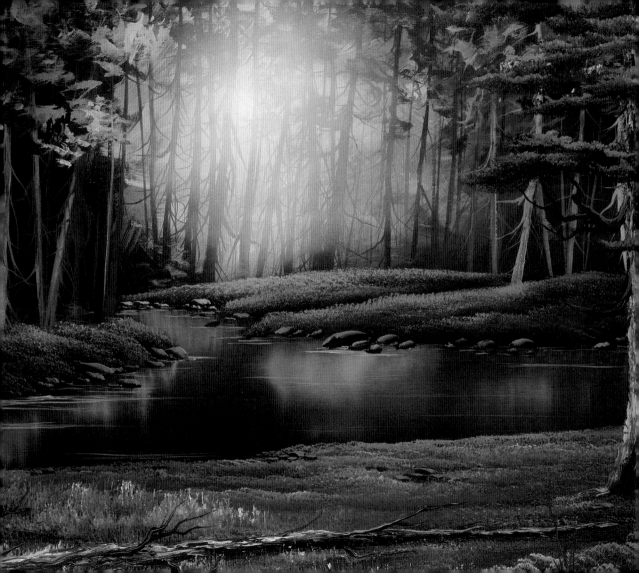

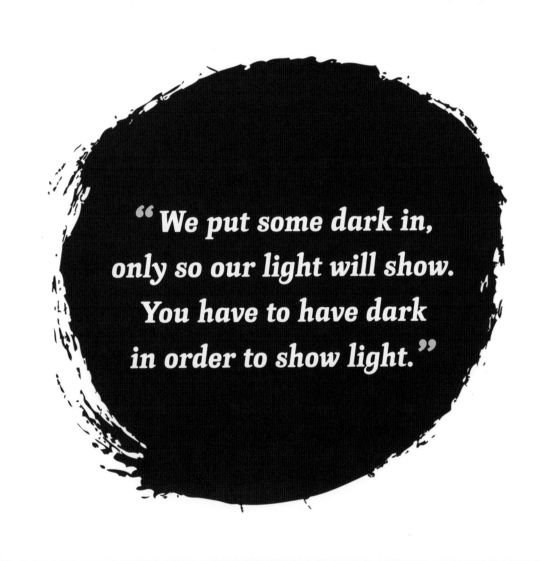

"We put some dark in, only so our light will show. You have to have dark in order to show light."

"This is your bravery test.
You worked so hard
and then a crazy-haired guy
tells you to throw in a
big ol' tree on top of it all.
Take a two-inch brush …"

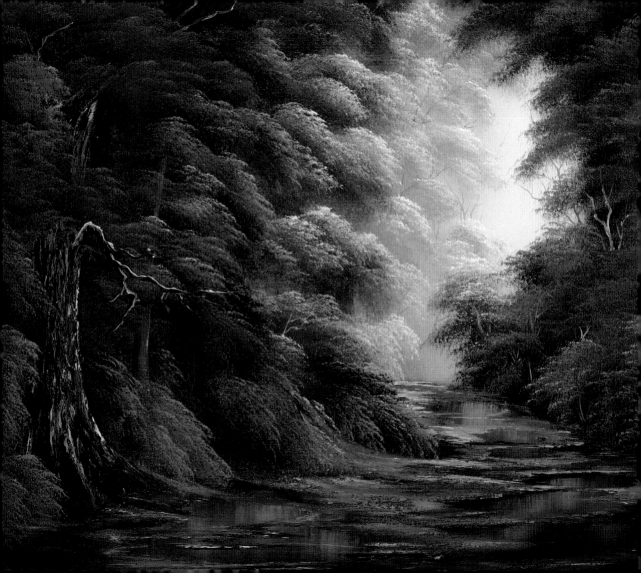

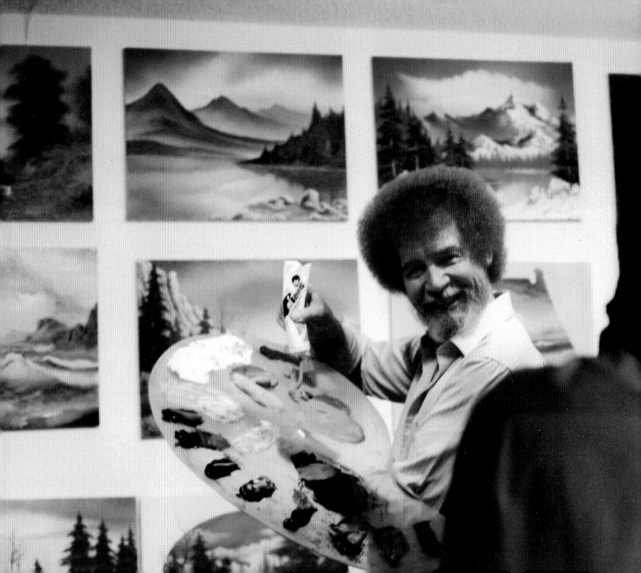

"It's very easy to add more color, but it's a son of a gun to try to take it off."

"Sometimes you learn more from your mistakes than you do from your masterpieces."

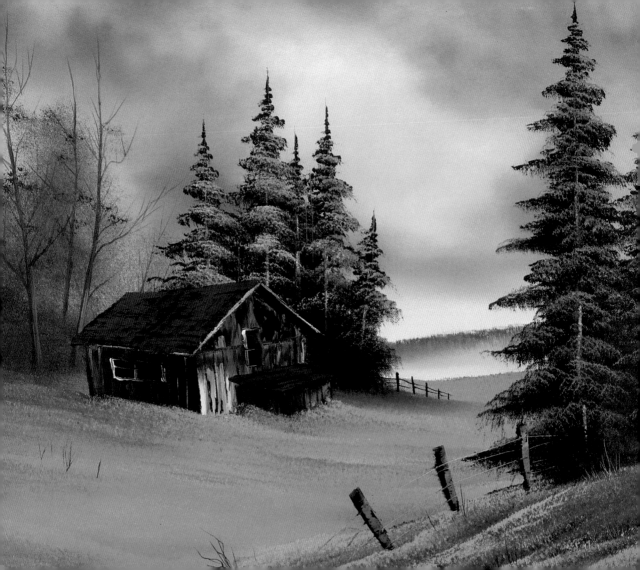

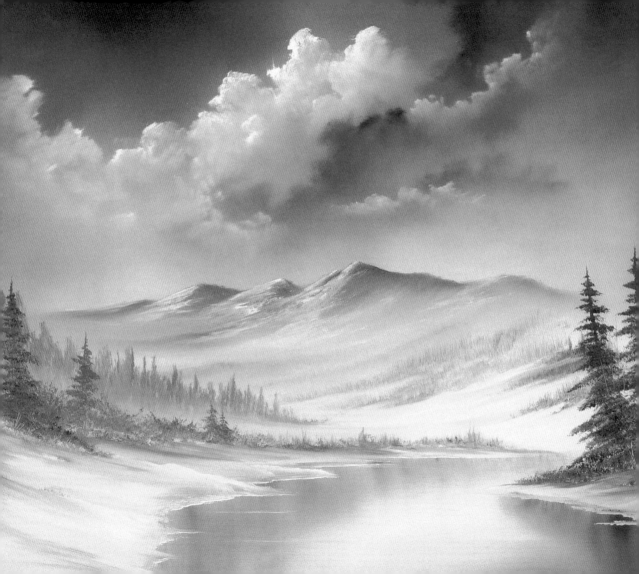

"The secret to doing anything is believing that you can do it. Anything that you believe you can do strong enough, you can do. Anything. As long as you believe."

" There's an artist hidden at the bottom of every single one of us. "

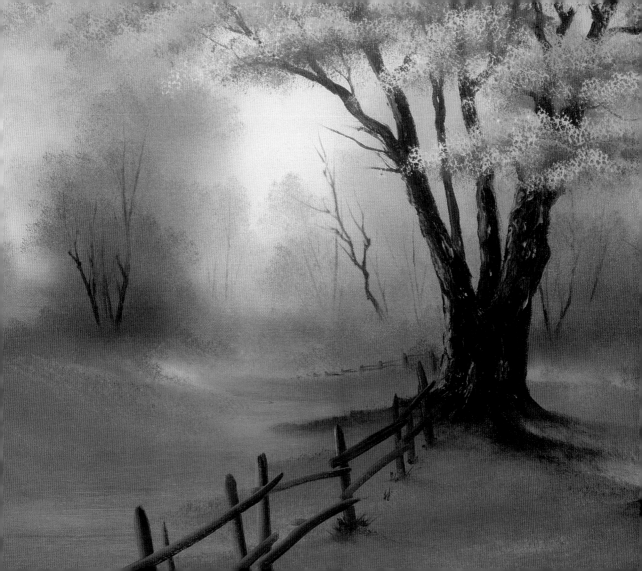

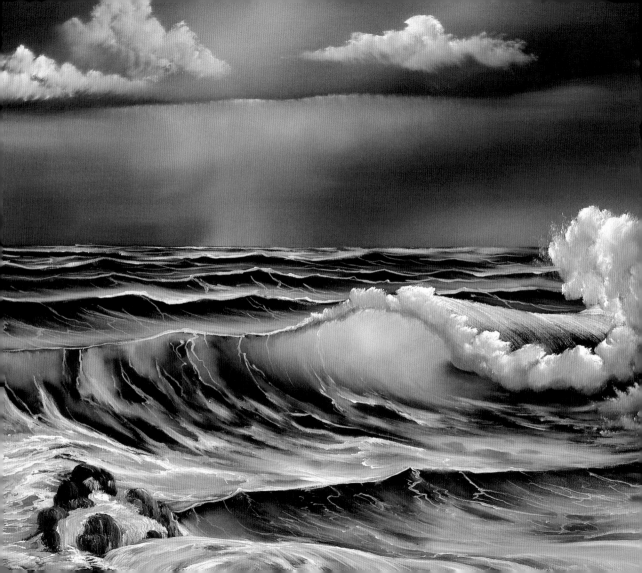

"Talent is a pursued interest. Anything that you're willing to practice, you can do."

"**In painting, you have unlimited power. You have the ability to move mountains. You can bend rivers. But when I get home, the only thing I have power over is the garbage.**"

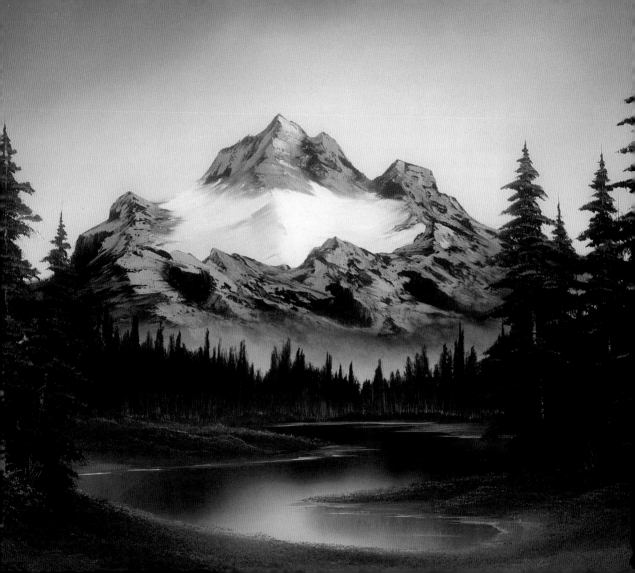

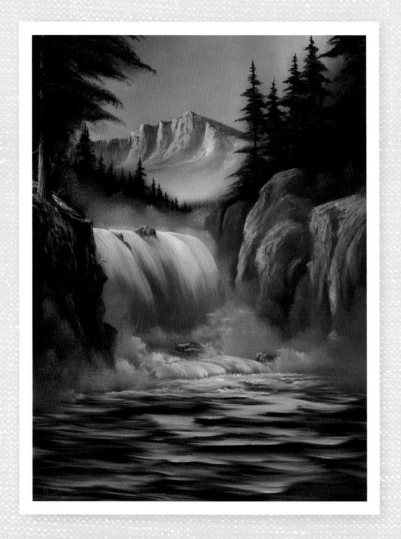

" *Just let go–and fall like a little waterfall.* "

"Trees cover up a multitude of sins."

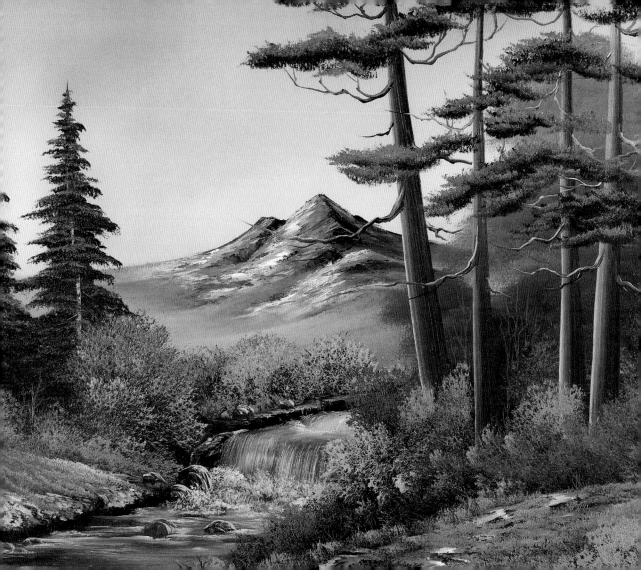

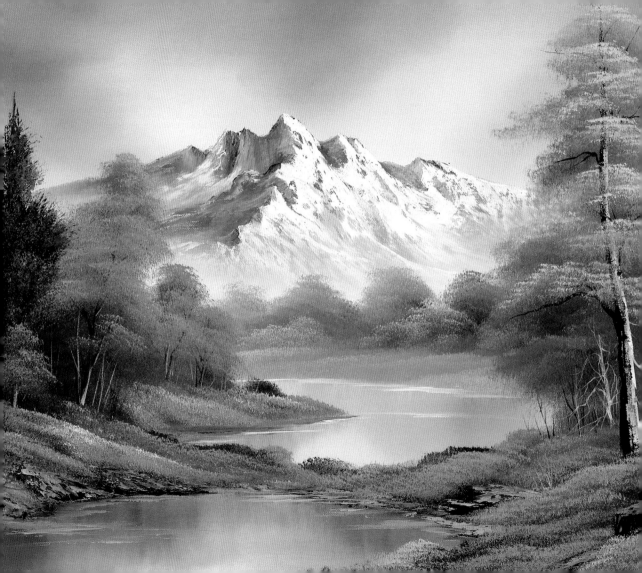

" **This is not something you should labor over or worry about. If painting does nothing else, it should make you happy.** "

"You have to allow the paint to break to make it beautiful."

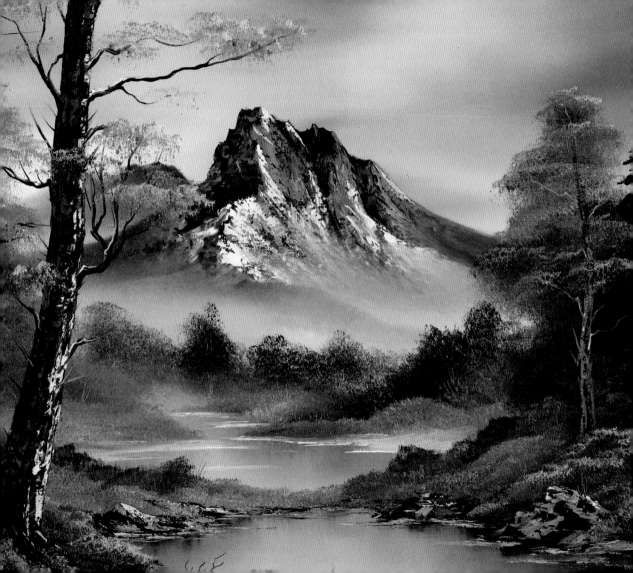

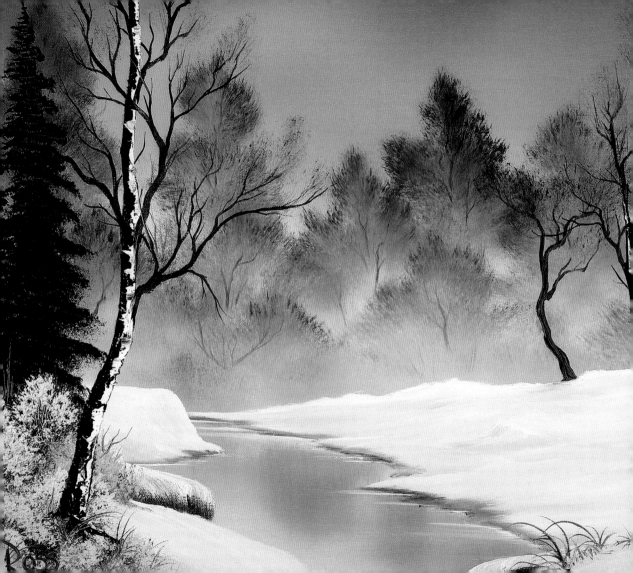

"**However you think it should be, that's exactly how it should be.**"

" **In nature,
dead trees are
just as normal
as live trees.** "

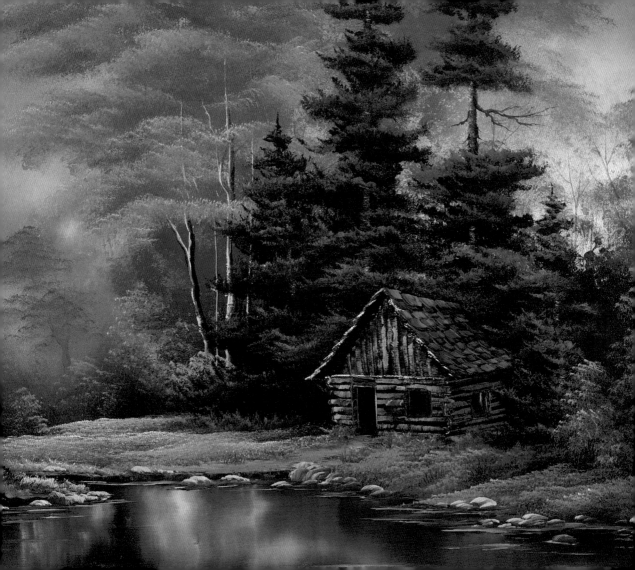

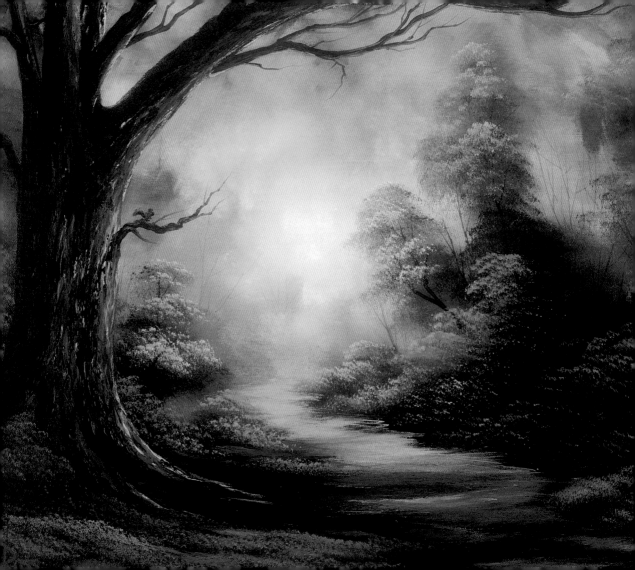

"We don't really know where this goes, and I'm not sure we really care."

"It's the imperfections that make something beautiful. That's what makes it different and unique from everything else."

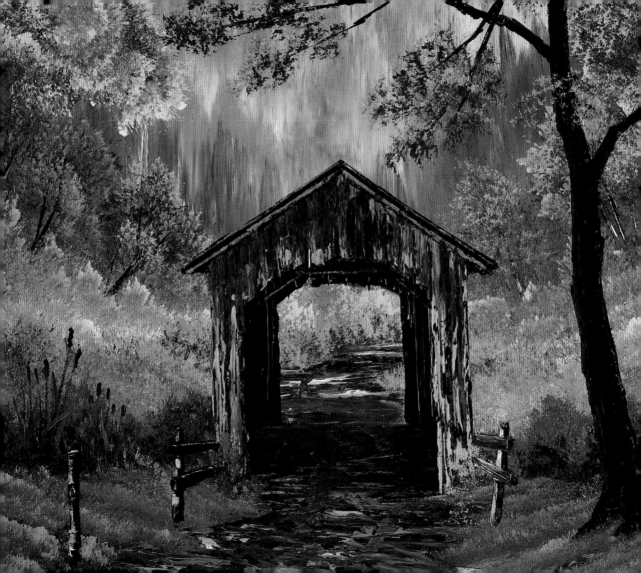

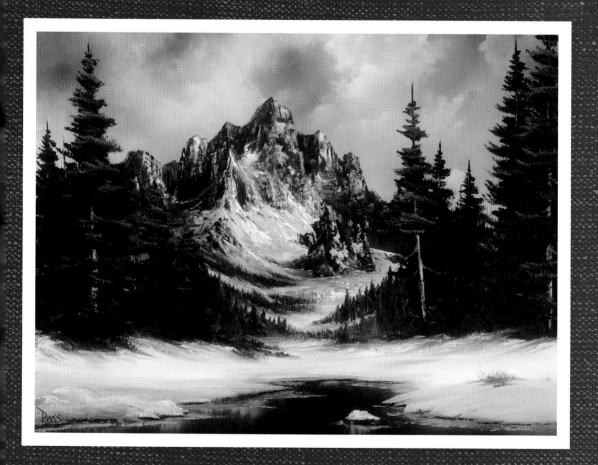

" Put light against light–you have nothing. Put dark against dark–you have nothing. It's the contrast of light and dark that each gives the other one meaning."

"All it takes is just a little change of perspective and you begin to see a whole new world."

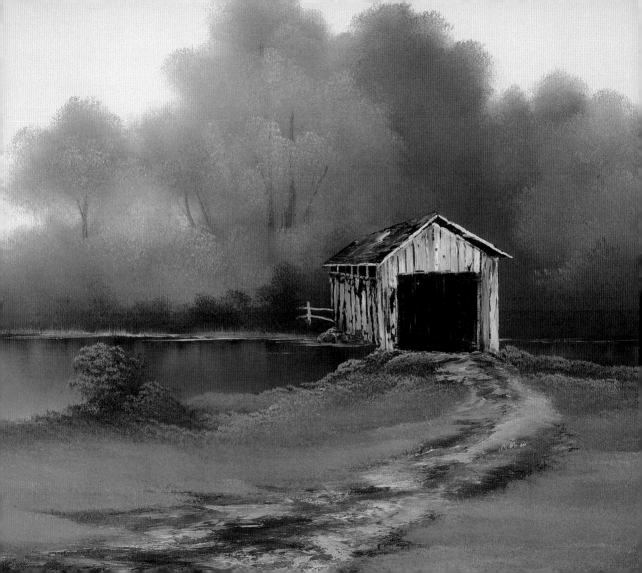

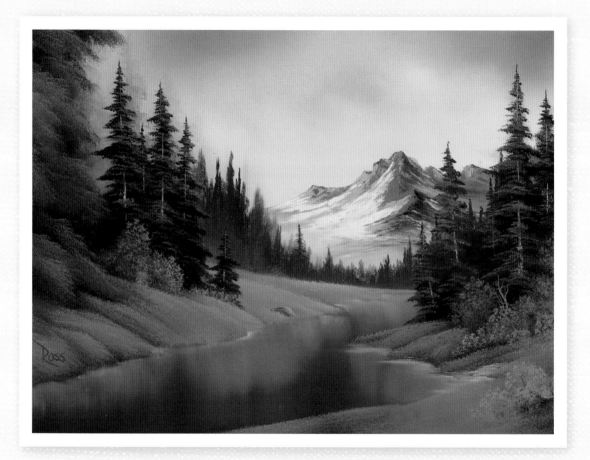

"Take your time.
Speed will
come later."

"**If it's not what you want, stop and change it. Don't just keep going and expect it will get better.**"

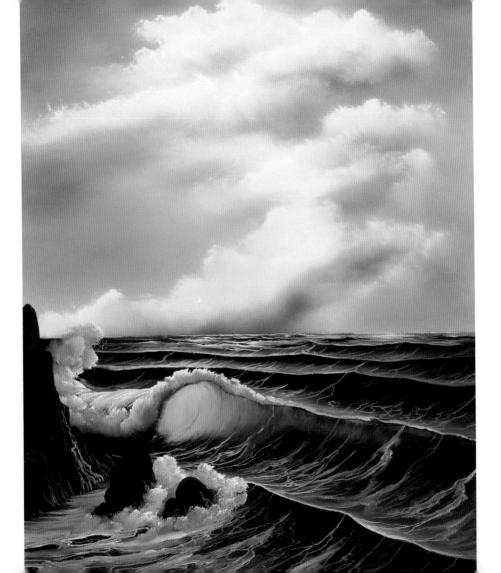

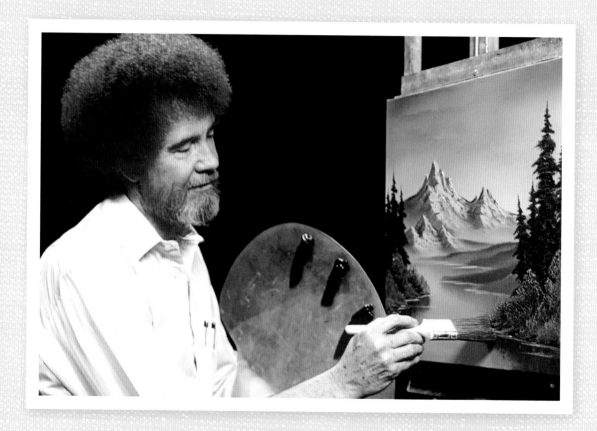

"I can't think of anything more rewarding than being able to express yourself to others through painting."

"**Let's make some nice, little clouds that just float around and have fun all day.**"

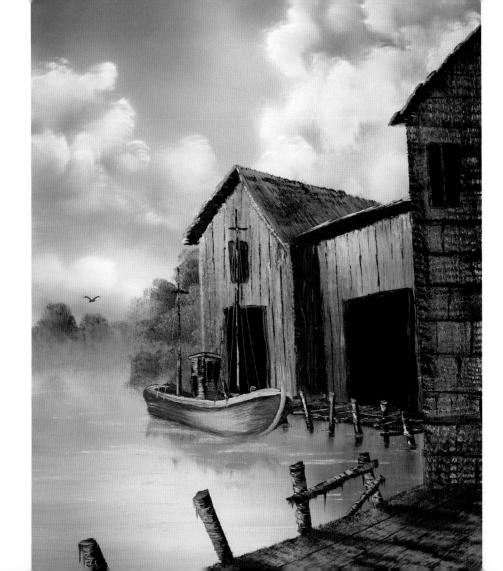

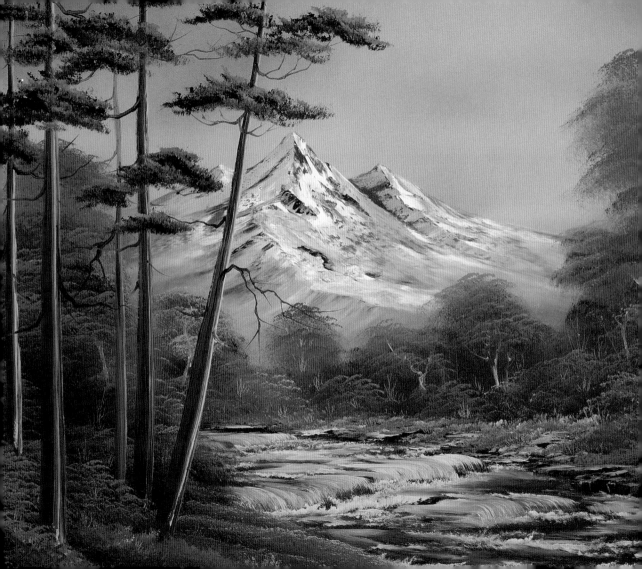

"We each see the
world in our own way.
That's what makes it
such a special place."

"Just beat the devil out of that old brush. It's a good way of taking out all your frustrations and hostilities and all that."

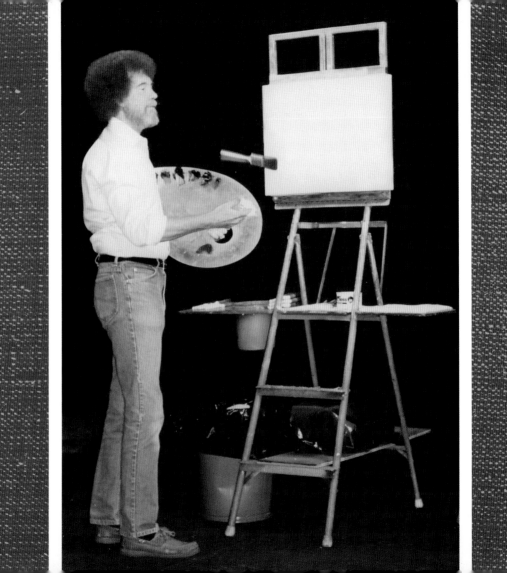

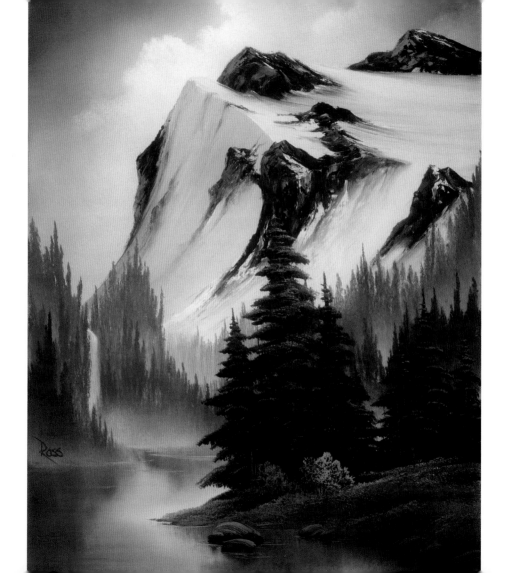

"That's when you experience joy–when you have no fear."

"This would be a good place for my little squirrel to live."

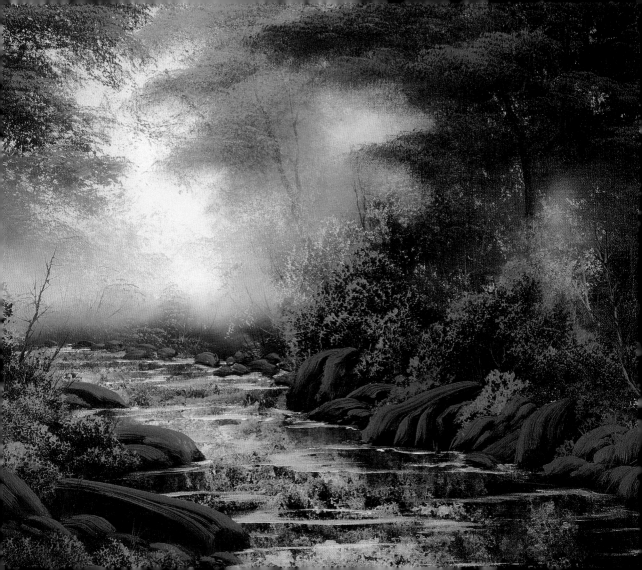

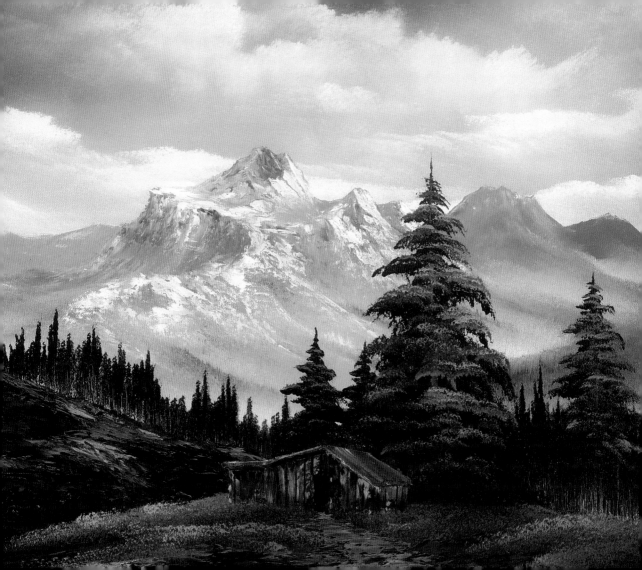

"Every single thing in the world has its own personality, and it is up to you to make friends with the little rascals."

"**Don't be afraid to scrape the paint off and do it again. This is the way you learn: trial and error, over and over, repetition.**"

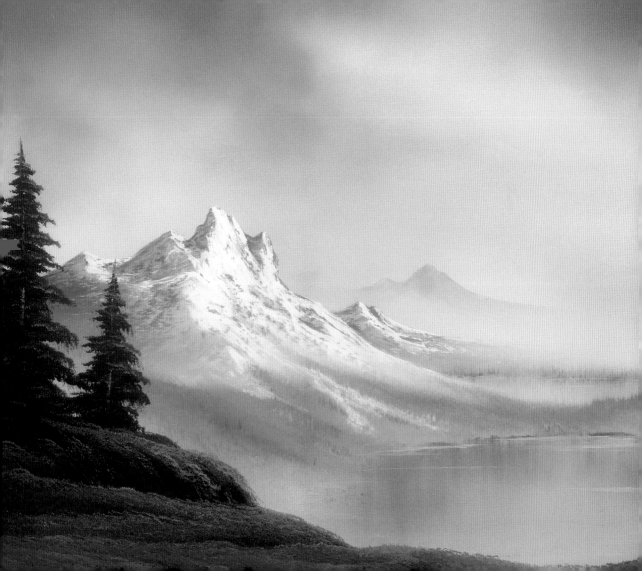

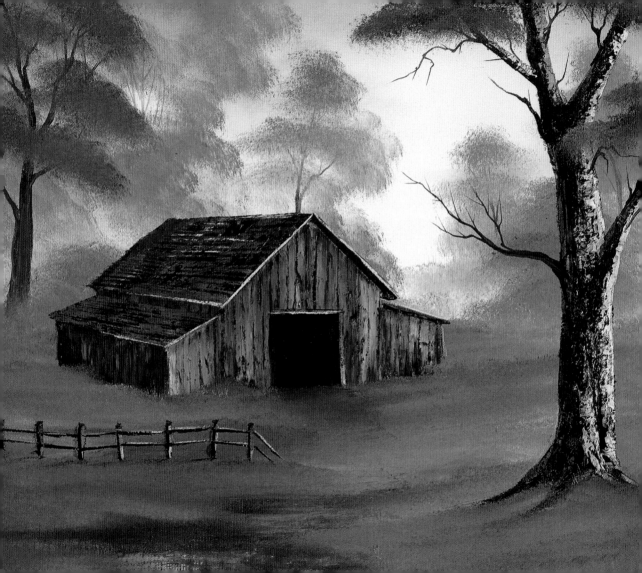

"A big, strong tree needs big, strong roots."

"Trees grow in all kinds of ways. They're not all perfectly straight. Not every limb is perfect."

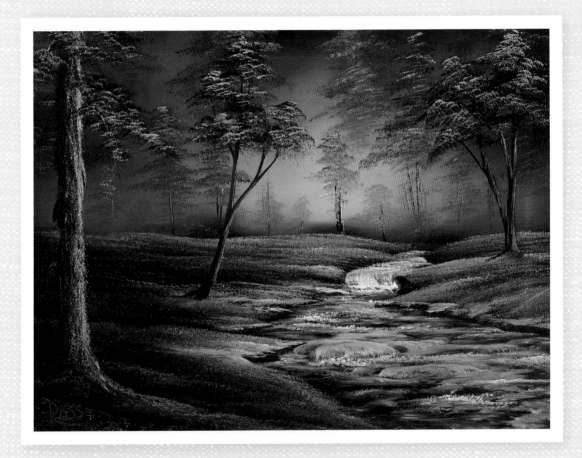

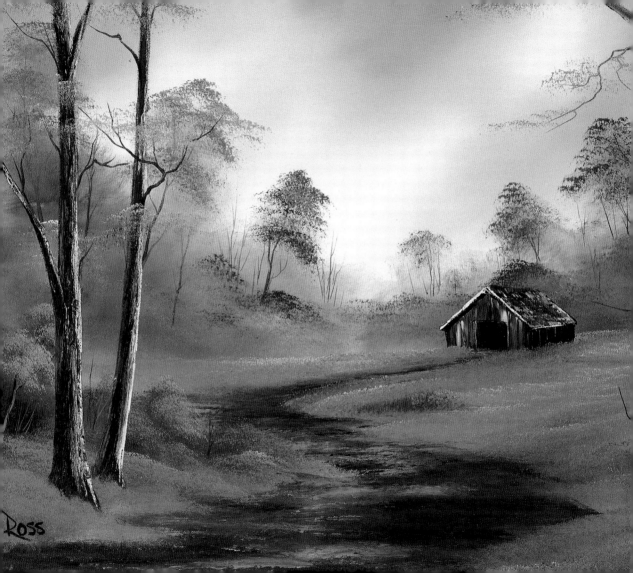

"These things live right in your brush, all you have to do is shake them out."

"We spend so much
of our life looking but
never seeing."

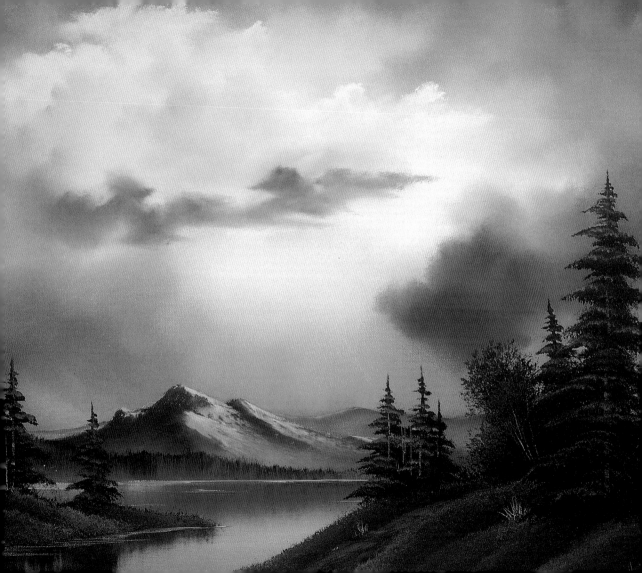

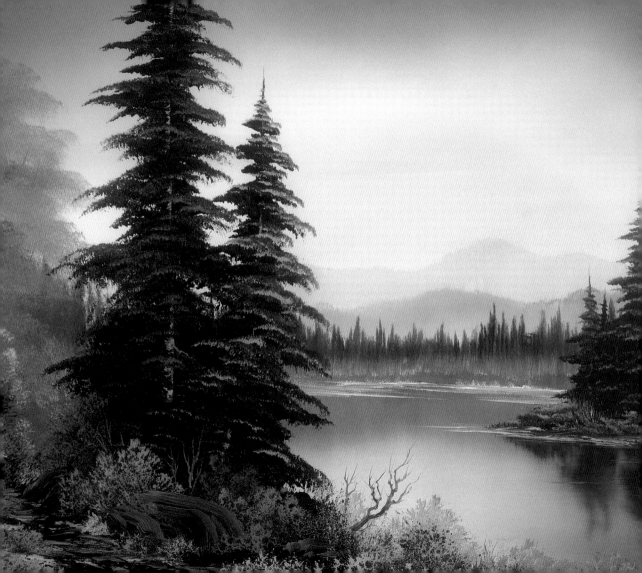

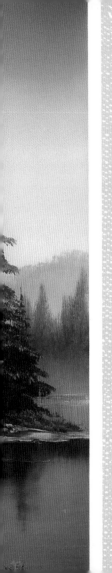

*" Always do the thing,
in your mind, that's
farthest away first.
Then work forward,
forward, forward. "*

"Just let your imagination go. You can create all kinds of beautiful effects, just that easy."

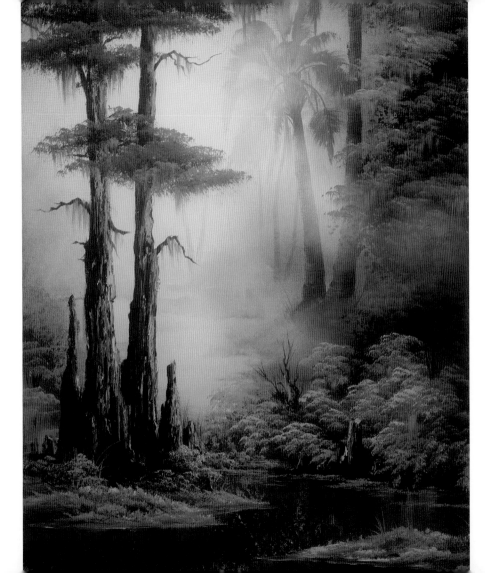

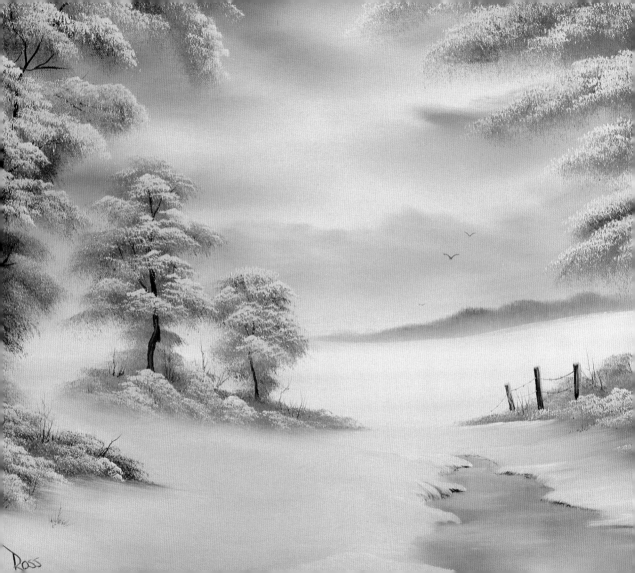

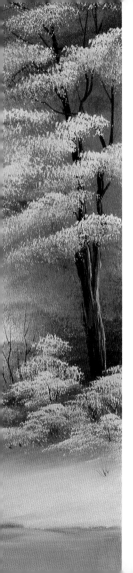

"**Every day is a good day when you paint.**"

"I think each of us,
sometime in
our life, has
wanted to paint
a picture."

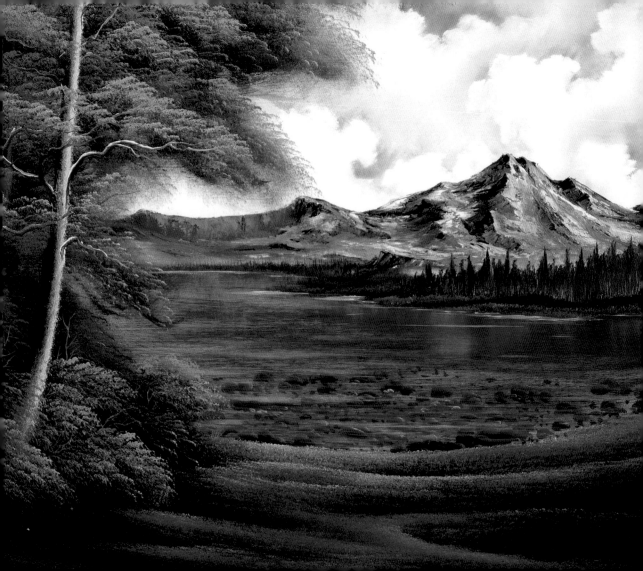

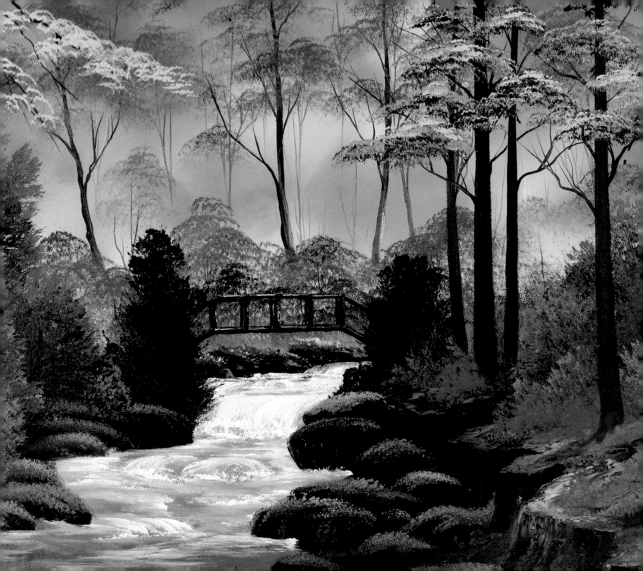

"You can do anything here—
the only prerequisite is that it
makes you happy."

"Don't be afraid to
go out on a limb,
because that's where
the fruit is."

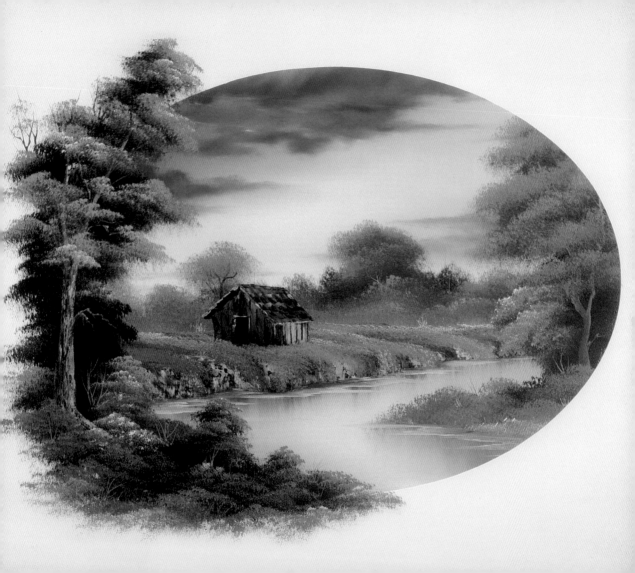

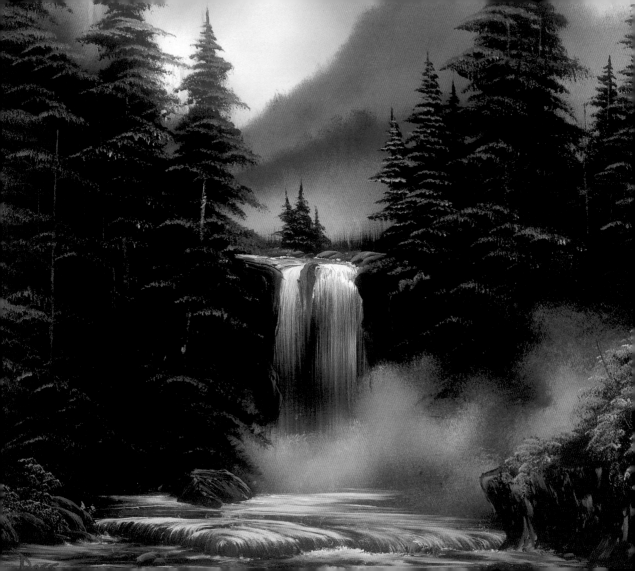

" **We have no limits to our world. We're only limited by our imagination.** *"*

"Exercising the imagination, experimenting with talents, being creative . . . these things, to me, are truly the windows to your soul."

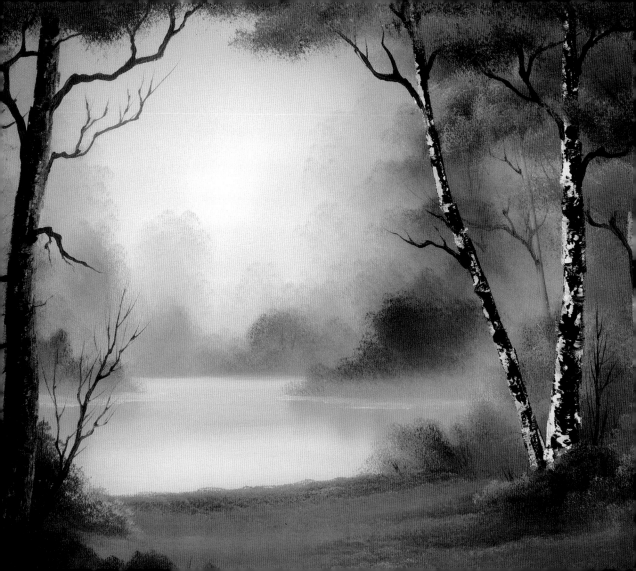

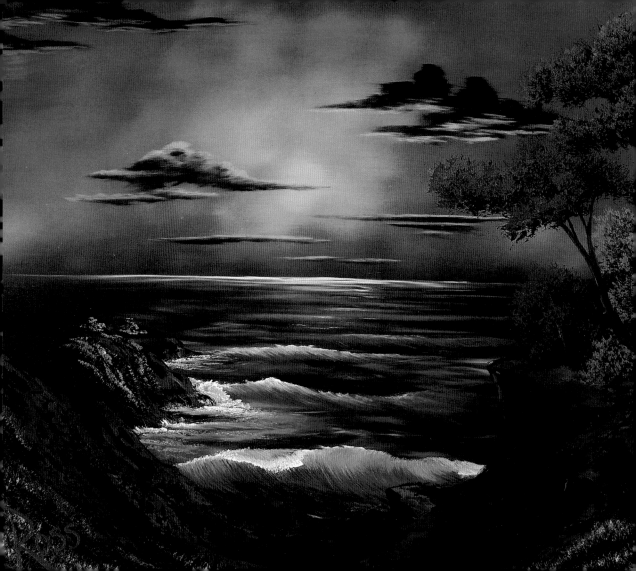

"**In life you need colors.**"

"You can create beautiful things, but you have to see them in your mind first."

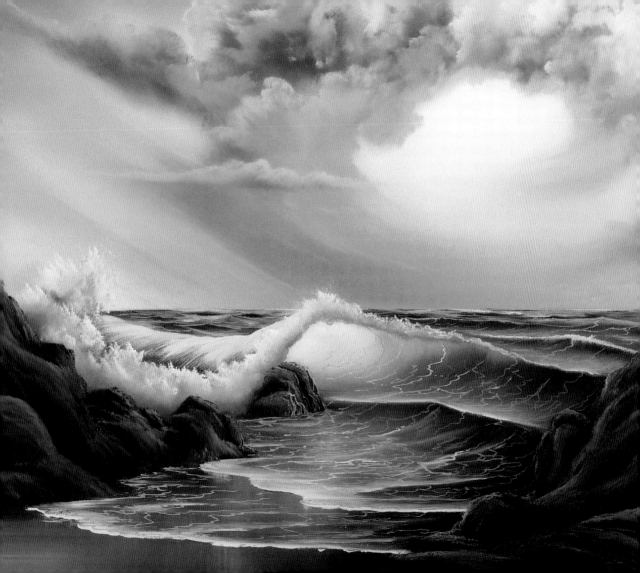

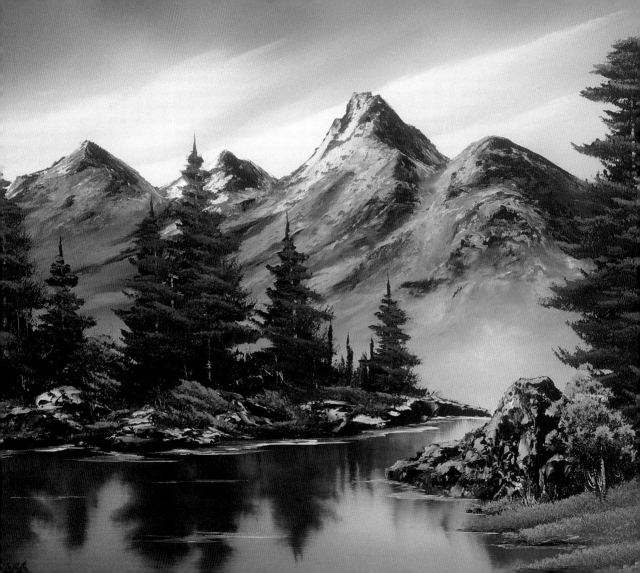

"There is immense
joy in just watching
all the little
creatures in
nature."

"You know me, I think there ought to be a big old tree right there. And let's give him a friend. Everybody needs a friend."

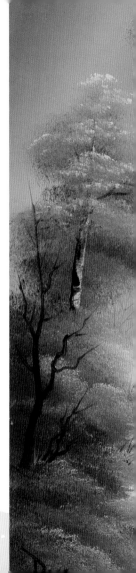

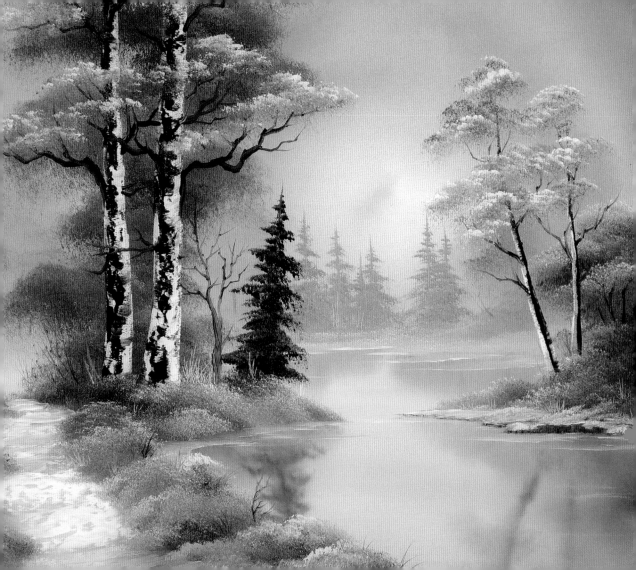

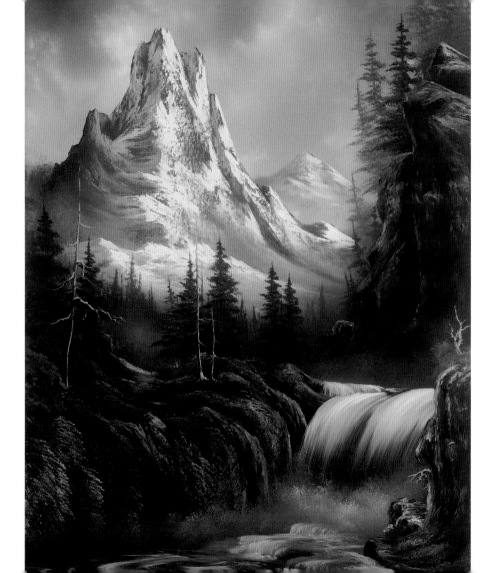

"You're the greatest thing that has ever been or ever will be. You're special. You're so very special."

"Isn't it great to do something you can't fail at?"

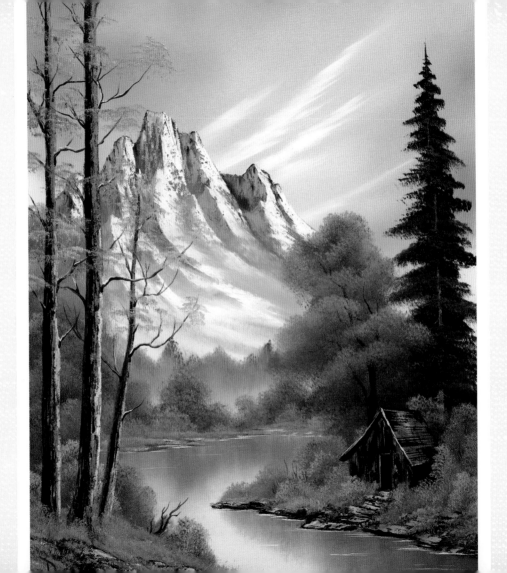

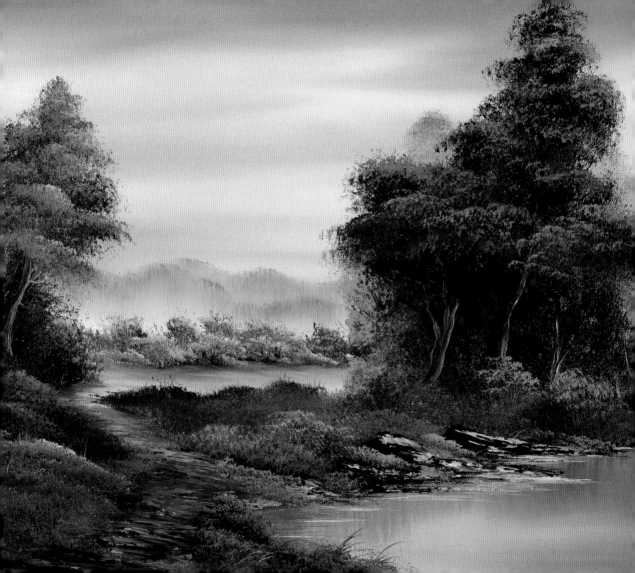

" A tree cannot be straight if it has a crooked trunk. "

"Any little thing can
be your friend if
you let it be."

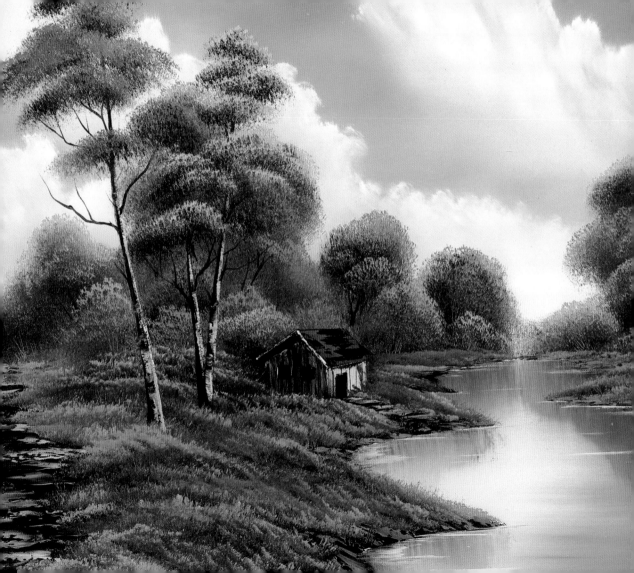

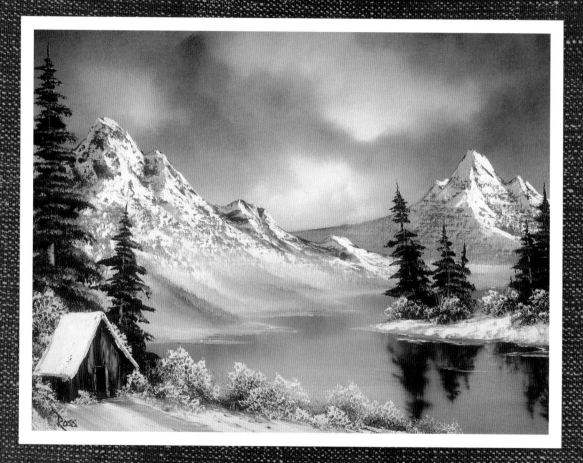

"The very fact that you're aware of suffering is enough reason to be overjoyed that you're alive and can experience it."

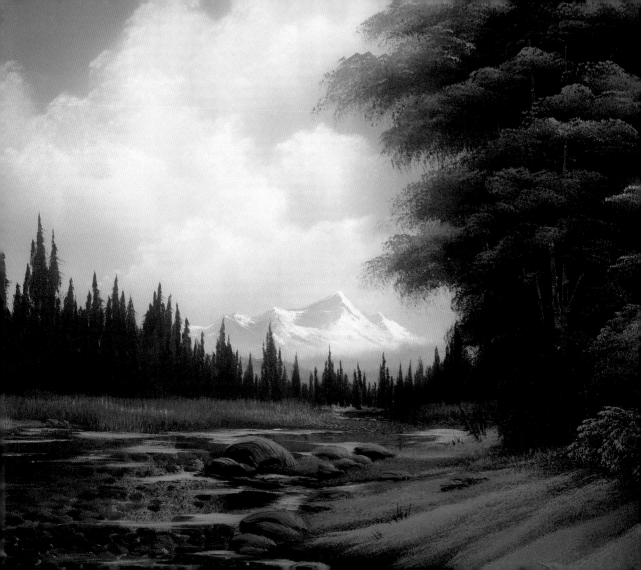

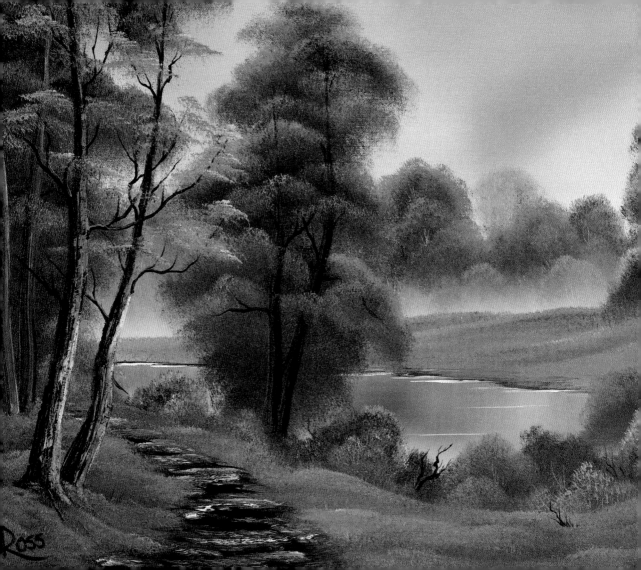

"There's beauty in every tree and every bush. Just take the time to look at 'em."

"**If what you're doing doesn't make you happy, you're doing the wrong thing.**"

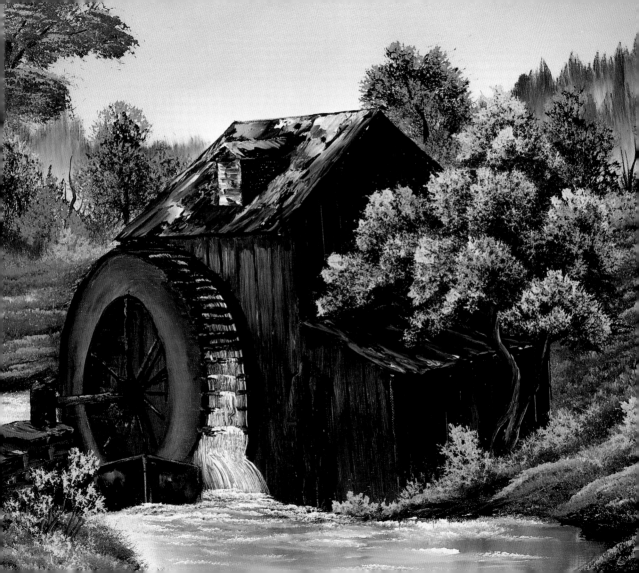

"If painting teaches you nothing else, it'll teach you to appreciate some of the beauty that's around us every day that we take for granted."

Bob Ross